THE HAPPY LITTLE BOOK OF

PUGS

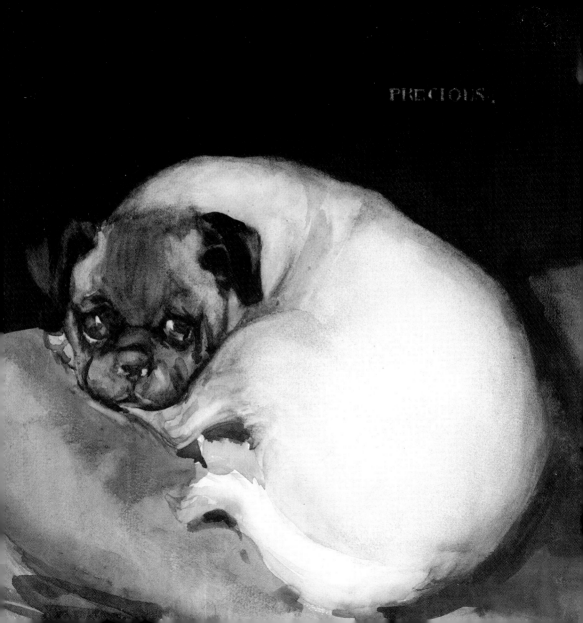

PRECIOUS.

THE HAPPY LITTLE BOOK OF

PUGS

A VISUAL APPRECIATION

KAY SCHUCKHART

COLLINS | DESIGN
An Imprint of HarperCollinsPublishers

¹pug \ 'pəg \ *n* [obs. *pug* hobgoblin, monkey] (1789)

1 : a small sturdy compact dog of a breed of Asian origin with

a close coat, tightly curled tail, and a broad wrinkled face.

THE JESTER WHO WOULD BE KING

Were Pugs put on Earth to be our little clowns? Or are these comic companions and tenacious protectors a product of centuries of breeding?

The historical record leans toward nurture over nature and shows that since ancient times, these delightful dogs have been carefully cultivated to bring a smile to the face and warmth to the laps of their owners.

Pugs have appeared in history for the last two and a half millennia. Records and illustrations of Pugs and Pug-like dogs appear in Chinese manuscripts dating back as far as 400 B.C.

Europeans may have "opened" trade with China by military means, but it was the Pug that conquered Europe. Early sixteenth-century sailors were said to have taken the small dogs home to the Netherlands, where they quickly assumed their rightful place—on the laps of kings and queens.

Napoléon Bonaparte's wife Joséphine had a Pug named Fortune, which, legend has it, bit the diminutive emperor as he entered his lady's bedchamber on the couple's wedding night in 1796. Not only did Fortune survive this contretemps, but Napoléon was so impressed by the Pug, he praised the breed above all others.

In 1936, England's King Edward VIII may have abdicated the throne to marry the "woman I love," but through good times and bad neither he nor his American-born duchess, Wallis Simpson, ever renounced their retinue of Pugs. In fact, it is said that the Duke and Duchess of Windsor took their dogs with them to almost all social events. Their Pugs had personal chefs, ate their meals from silver dog dishes from F. B. Rogers Silver Company, and wore Miss Dior, the duchess's favorite fragrance. A Pug's life, indeed!

In recent decades the Pug has been celebrated in popular culture high and low, from the classic children's book *Eloise* to films as varied as *The Adventures of Milo and Otis*, *Pocahontas*, and *Men in Black*. Pugs have starred in television commercials selling everything from asthma medication to credit cards.

From their nonlinear crablike amble to their enthusiastic scoot-and-scamper maneuver, their outsized snore and affinity for cuddles and slumber, Pugs are the world's most affectionate companions—silly and devoted clowns with plaintive eyes and a distinct lack of pretense or guile. No wonder they continue to seduce and enchant owners to this day.

PUG MOTTO:

MU
INPA

LTO
RVO

LATIN FOR:

a lot of dog in a small space.

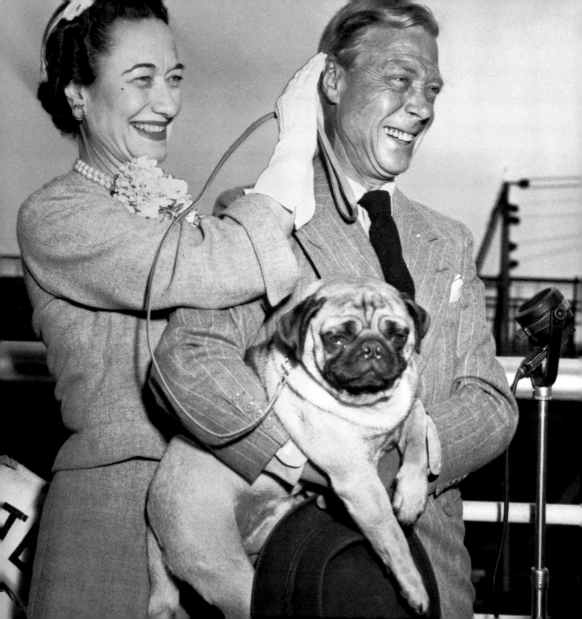

THE *Perfect* PUG

LEGS AND FEET
should not be too short or too long. Toenails should be black.

COAT
should be smooth and glossy.

COLORING
Pugs should be fawn, black, or, more rarely, apricot. Markings on the face should be as black as possible and well defined.

HEAD
should be large and round with no apple-shaped indentation in the skull. Eyes should be large and round with little or no white around the iris. Ears should be velvety smooth. A slight underbite is desirable.

BODY
should be square, cobby, and wide in the chest.

TAIL
should be tightly curled. A single curl is acceptable, but the double curl is considered perfection.

NECK
should be strong and thick.

In the Confucian era, Chinese documents make allusions to short-nosed dogs.

Trade opens between China and Portugal, bringing the Pug to Europe.

The first European Pug is depicted in a painting entitled *Madame de Ventadour with Portraits of Louis XIV and Heirs* by an unknown artist.

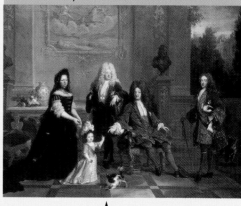

400 B.C. 169–190 A.D. 1517 1572 1714 1730

Emperor Ling To is so smitten with his Pugs that he gives the females the same ranking as his wives.

William the Silent, the Prince of Orange, is saved by his Pug from a surprise attack on his camp by Spanish forces. The Pug becomes the symbol for the House of Orange.

William Hogarth depicts a black Pug in his painting *The House of Cards.*

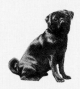

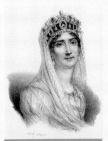

Joséphine de Beauharnais weds Napoléon Bonaparte. She brings her Pug, Fortune, with her to the household.

The United Kingdom's Pug Dog Club is formed by a group of Pug enthusiasts. Mrs. M. Holdsworth, the first woman to judge a dog show in the United Kingdom, is nominated as secretary.

The Pug Dog Club of America is formed by a group of East Coast breeders and exhibitors.

Ch. Dhandy's Favorite Woodchuck wins Best in Show at Westminster.

1796 1837–1901 1883 1885 1931 1945 1981 1982–PRESENT

Pugs are popularized by Queen Victoria.

The Pug is officially recognized as a breed by the American Kennel Club.

Ch. Udalia's Mei-Ling, a female, is the first Pug to win the Toy Group at Westminster.

The breed's popularity grows, due in part to Pugsploitation in film, literature, and advertising.

PUG PERK Pugs are fastidious by nature and enjoy taking baths.

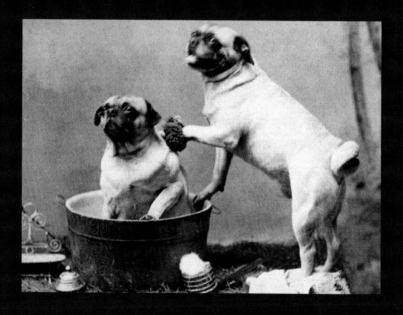

PUG QUIRK Pugs shed. A lot. A whole lot. Constantly.

A Hot Sport.

Be it basic black, or the classic combination of tan and black,
the Pug always comports itself with a great sense of style.

A PUG LEXICON

Pugacea—('pug e sē´ a), n. A remedy for all ailments. Pugs are a wonderful pugacea when you are feeling blue or ill.

Pugafist—('pug a fist), n. One who is strongly opposed to conflict, especially war. Pugs are by nature a peace-loving breed.

Pugchant—('pug chant; Fr. päɴ shän´), n. Strong inclination. Pugs have a pugchant for napping.

Pugculiar—('pug kyool yer), adj. Strange; queer; odd. Pugs have pugculiar faces.

Pugfunctory—('pug fungk´ te rē), adj. Characterized by routine duty. It is pug-functory for Pugs to sleep twenty-two hours a day.

Puggan—('pug gen), n. A nonmeat- or nondairy-consuming Pug. A mythological creature.

Pugitent—('pug i tent), adj. Feeling sorry or remorseful. See *Pugpetrate*.

Pug 10 in. (25 cm) high at shoulder

Puglygamy—('pug lig´ e me), n. The practice or condition of having more than one pug at a time. Most Pug owners are puglygamists.

Pugnache—('pug nash´, näsh´), n. A grand or flamboyant manner; verve; style; flair. All Pugs have a certain pugnache.

Pugody—('pug e dē), n. pl. -dies, v., -died, -dying.—n. A humorous or satirical imitation of "real" dog behavior.

Pugpetrate—('pug pi trait´), v. t., -trated, -trating. To commit a crime. Pugs have been known to pugpetrate unattended sandwiches left on low-lying tables. After being caught, Pugs are pugitent.

Pugpetual—('pug pech´ oo el), adj. Enduring. Pugs have a pugpetual loyalty and love for their masters.

Pugplexed—('pug plekst´), adj. Puzzled. More often than not, Pugs are pugplexed by the smallest thing.

Pugseverance—('pug´ se ver´ ens), n. Steady persistence in a course of action, a purpose, for gaining food or affection.

Pugssess—('pug zes´), v., To have and hold as property: to own. Most Pugs completely pugssess the hearts and homes of their owners.

Pugticipate—('pug tis´ e pāt´), v., -pated, -pa•ting. To take or have a part or share, as with others. Pugs will happily pugticipate in an afternoon nap with their humans.

Pugtrol—('pug trōl´), v., -trolled, -trolling. To pass around the kitchen pugtrolling for scraps or crumbs.

Pugtron Saint—('pug tren sānt), n. Personal saint a Pug prays to for food and related miracles.

Pugtrician—('pug trish´ en), n. A pug of high birth: aristocrat. Often the favorite pets of royalty and nobility, the breed is truly pugtrician.

Pugtronage—('pug tre nij, pa´-), n. Distribution of favor. Pugs show great pugtronage to those who shower them with either affection or treats.

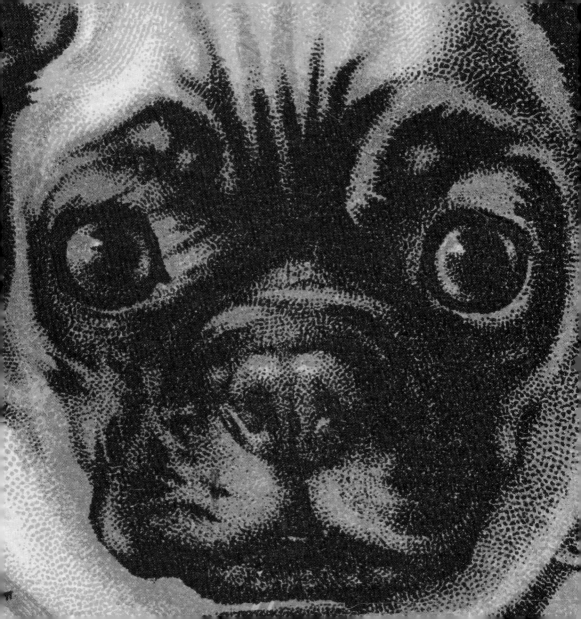

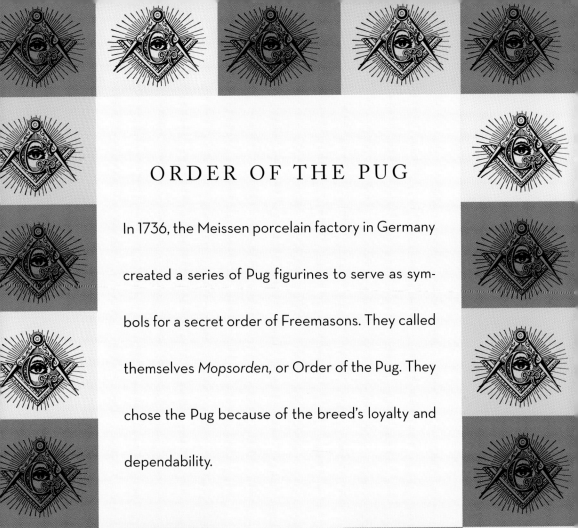

ORDER OF THE PUG

In 1736, the Meissen porcelain factory in Germany created a series of Pug figurines to serve as symbols for a secret order of Freemasons. They called themselves *Mopsorden*, or Order of the Pug. They chose the Pug because of the breed's loyalty and dependability.

PUG PERK Pugs play well with children.

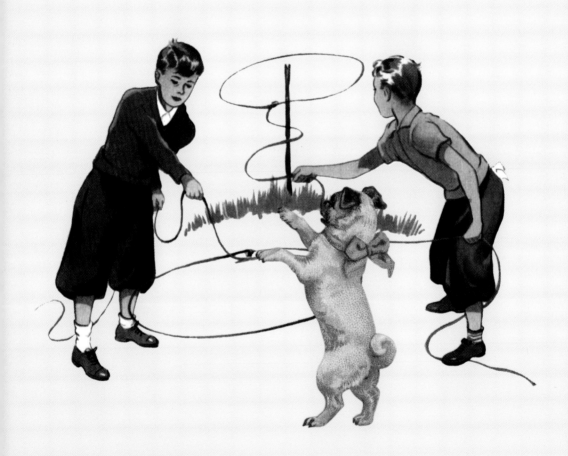

PUG QUIRK Pugs snore. Loudly.

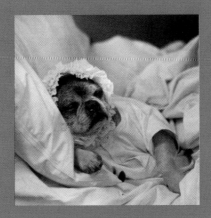

PUG STANDARD TIME

The typical Pug day is chockablock with fun and exciting things to do.
Here's a typical action-packed schedule.

7 A.M. Wake with humans.

8 A.M. *STILL IN BED.*

8:30 A.M. Out for business.

8:35 A.M. BREAKFAST.

8:45 A.M.–12 P.M. BACK TO BED.

8:40 A.M. Start barking at paper bag for no reason.

12:01 P.M. Bark at postman.

12:02 P.M. BACK TO BED.

3 P.M. Bark at leaf blowing down the street.

3:05 P.M.

BACK TO BED.

4 P.M.
Start begging for dinner.

5:00–5:30 P.M.
Walk. More business.

5:35 P.M. # DINNER. *FINALLY.*

5:40 P.M.
Begin high-pitched whimpering for treat.

5:45 P.M.
Humans succumb. Consume after-dinner treat.

6:00–10:55 P.M.
Snooze and snore loudly in front of the television set.

11 P.M. # TO BED. *EXHAUSTED.*

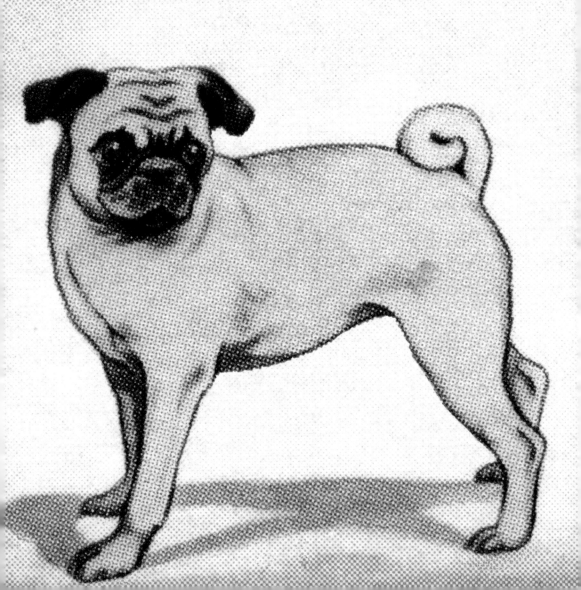

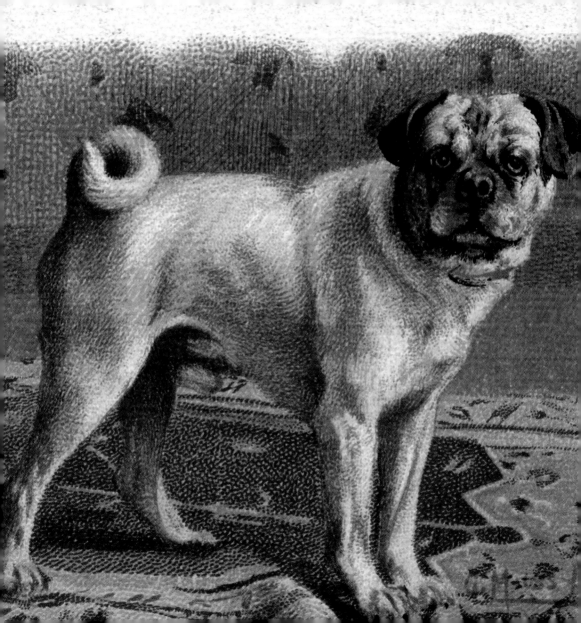

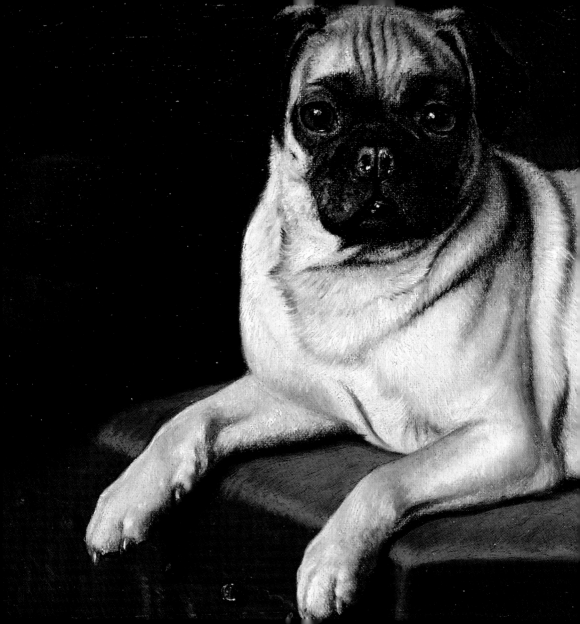

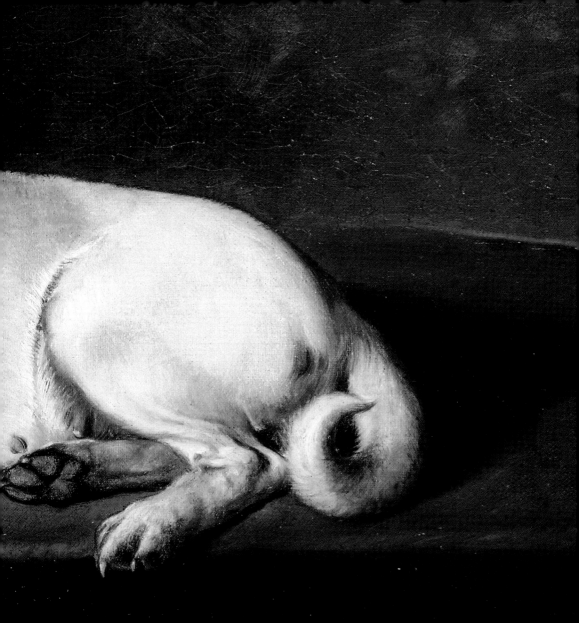

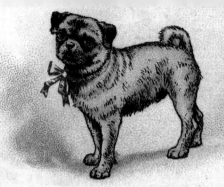

PUG.

PUG.

PUG.

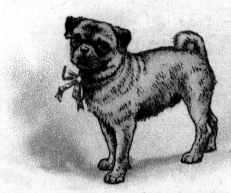

PUG.

PUG.

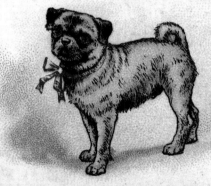

PUG.

I see the tail, like a bracelet twirled, In moments of disgrace uncurled, Then at a pardoning word re-furled. — Matthew Arnold

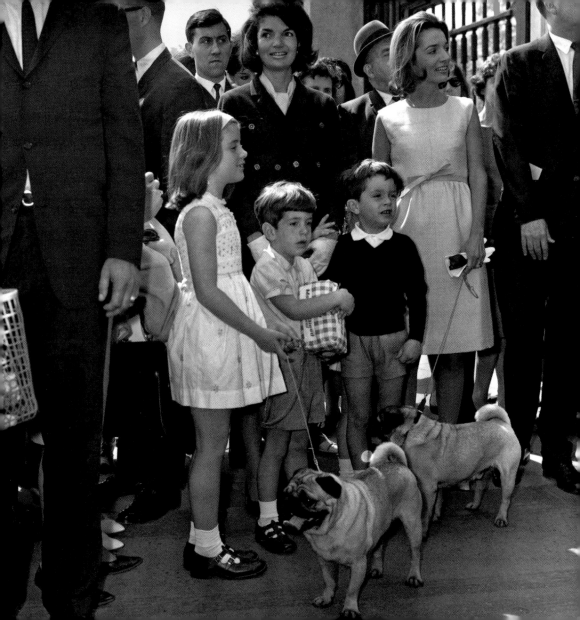

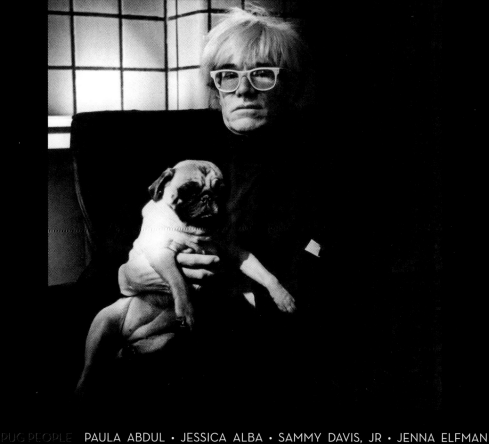

PUG PEOPLE PAULA ABDUL · JESSICA ALBA · SAMMY DAVIS, JR · JENNA ELFMAN

LENA HORNE · BILLY JOEL · JACQUELINE KENNEDY ONASSIS · MICKEY ROURKE

TORI SPELLING · VALENTINO · VOLTAIRE · ANDY WARHOL · PAUL WINFIELD

Oh, what is the matter
Pet him and kiss him
Run and fetch him
Wrap him up ten
That is the way to

—Winston Churchill, on his

with poor Puggy-wug?

and give him a hug.

a suitable drug.

derly all in a rug.

cure Puggy-wug.

daughter Mary's pet pug

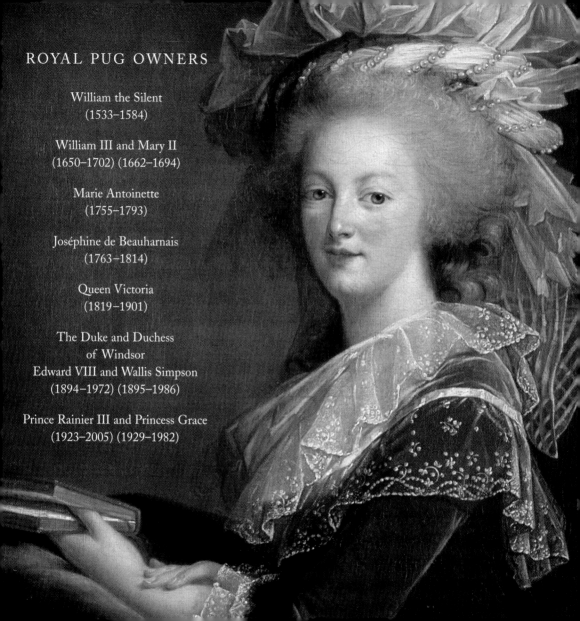

ROYAL PUG OWNERS

William the Silent
(1533–1584)

William III and Mary II
(1650–1702) (1662–1694)

Marie Antoinette
(1755–1793)

Joséphine de Beauharnais
(1763–1814)

Queen Victoria
(1819–1901)

The Duke and Duchess
of Windsor
Edward VIII and Wallis Simpson
(1894–1972) (1895–1986)

Prince Rainier III and Princess Grace
(1923–2005) (1929–1982)

Let the pugs eat cake.

PUG NOIR

The origin of the black Pug has always been a bit of a mystery. One widely held theory is that a certain Lady Brassey, a world traveler, brought the first two black Pugs into England in 1877, when she returned in her yacht the *Sunbeam* from China.

But evidence indicates otherwise: the painting *Interior of a Tailor's Shop* by Dutch artist Quiringh van Brekelenkam proves that black Pugs were in Europe as early as 1653, and British painter William Hogarth's *The House of Cards* (1730) disproves the theory, too. Queen Victoria owned several black pugs, which appeared in her photo albums as early as 1854.

Yet while Victoria may have owned several, Lady Brassey owned the most. The lady may not have introduced black Pugs into England, but she did make them fashionable in the late 1800s, and the dogs she bred set the standard in England for many years. Case closed.

PUG PHRENOLOGY

Phrenology, a popular pseudoscience in Victorian times, claimed that personality traits were determined by the shape and bumps of the skull. What would a phrenologist "feel" about our little friend?

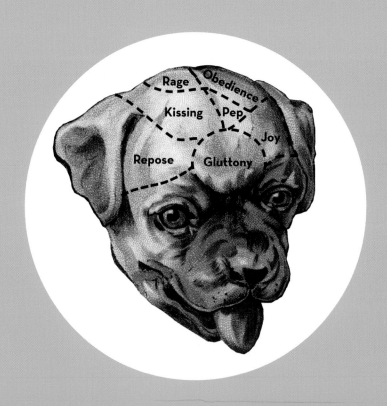

I would rather

have an army

of Dogs led by

a Pug than an

army of Pugs

led by a Dog.

—Napoléon Bonaparte

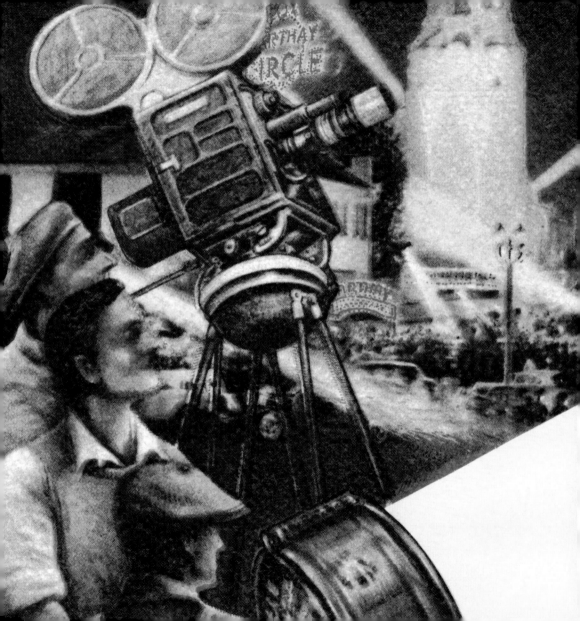

THE CINEMATIC PUG

Always the center of attention, Pugs adore performing for the camera.
What better way to secure mass love than a stint at movie stardom?
Here are some films that Pugs have graced with their charm and charisma.

THE GREAT RACE (1965) • DUNE (1984) • THE ADVENTURES OF MILO
AND OTIS (1989) • HEAVENLY CREATURES (1994) • POCAHONTAS (1995)
MEN IN BLACK (1997) • MANSFIELD PARK (1999) • RUNAWAY BRIDE
(1999) • 102 DALMATIANS (2000) • MEN OF HONOR (2000) • MONKEY-
BONE (2001).

Rambunctious

Happy

Playful

Mischievous

Charming

Loyal

Friendly

Clever

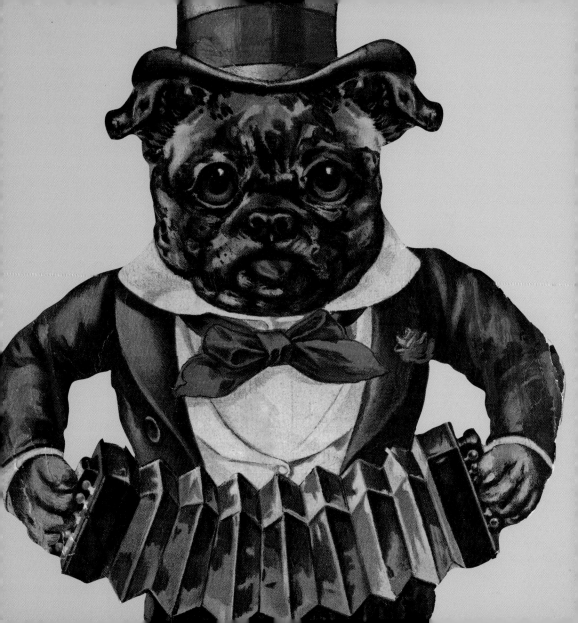

PUG PERK Pugs are adaptable to new situations. They travel well.

PUG QUIRK Pugs really, really enjoy their meals. If not carefully monitored, they are prone to gain weight. Pug owners must be diligent dieticians.

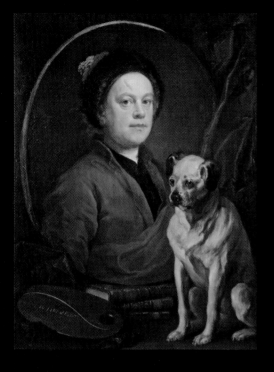

PUG PAINTERS · FRANÇOIS BOUCHER

GIACOMO ANTONIO CERUTI · MAUD EARL

JOHN EMMS · THOMAS GAINSBOROUGH

FRANCISCO DE GOYA · WALTER HARROWING

JOHANN HARTUNG · WILLIAM HOGARTH

LOUIS-MICHEL VAN LOO · JOHN SARGENT NOBLE · JOHN PAUL · PHILIP REINAGLE

CHARLES STEFFECK · GEORGES SEURAT · JAMES JACQUES JOSEPH TISSOT · CHARLES TOWNE

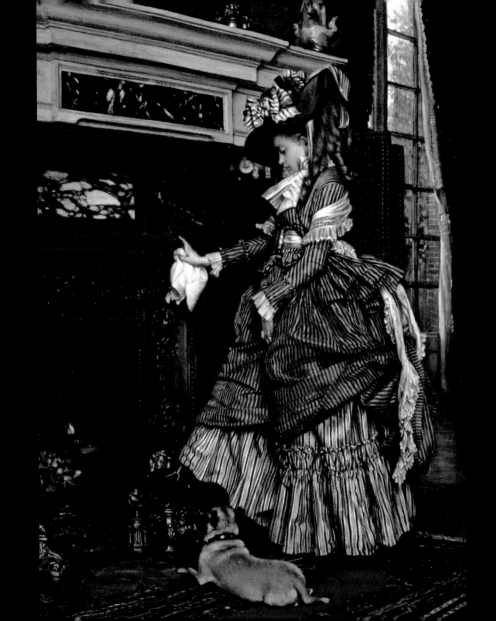

13 is the popularity ranking of the Pug in the United States.

11 Pugs were owned by the Duke and Duchess of Windsor during their lifetime. Among them were: Rufus, Dizzy, Davy Crockett, Impy, Gen Sengh, Winston, and Trooper.

42 teeth make a Pug's mouth complete.

12-14 inches is the average height of a Pug.

63 days is the average gestation period for a Pug.

6 Pugs named Molly, Milton, Monty, Margot, Maude, and Maggie are owned by fashion designer Valentino.

3 years is how long Pug puppyhood can last.

14–18 pounds is the desirable weight for a Pug according to the American Kennel Club.

3 puppies are born in the average Pug litter.

65 is the number of Best in Show awards Dermot (Ch. Kendonc's RiverSong Mulroney) has won at events across the United States, making him the most winning Pug to date.

13–15 years is the life expectancy of a Pug.

8 Pugs named Venus, Olga, Fatima, Pedro, Minka, Mops, Topsy, and Duchess were owned by Queen Victoria.

20 is where the Pug falls on the list of the most popular breeds in the United Kingdom.

14 hours a day is the average time a Pug spends asleep. Many Pug owners would say it seems like a lot more.

1966 is the year *Pug Talk* magazine was founded.

500 dollars is the average cost of a purebred Pug puppy.

32 Pug dog clubs are active across the world.

He would at Windsor
have taken possession of the
throne if he thought that it looked
comfortable enough, and been
surprised if asked to move.

—Anonymous member of Queen Victoria's palace staff,
on Basco, one of the royal Pugs

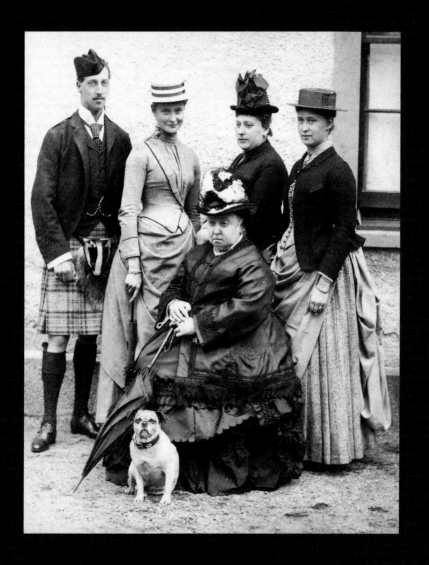

A Pug by any other name

MOPS HUND (German)

MOPS HOND (Dutch)

DOGUILLO (Spanish)

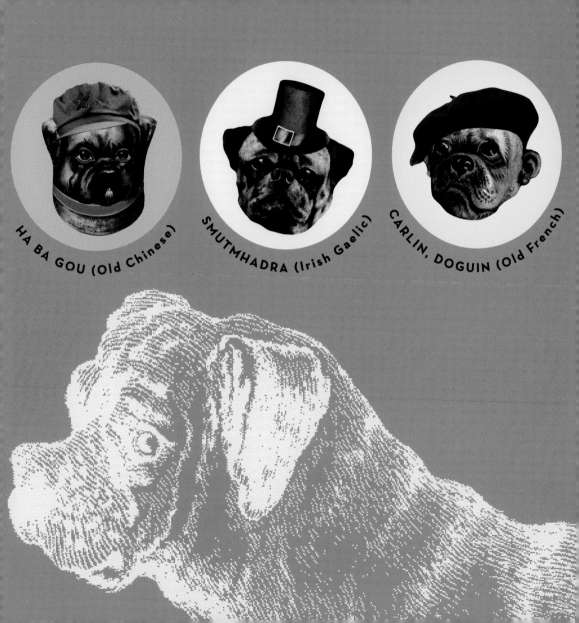

HA BA GOU (Old Chinese)

SMUTMHADRA (Irish Gaelic)

CARLIN, DOGUIN (Old French)

PUG QUIRK Low to the ground and lacking the long snout that helps other breeds cool down as they breathe, Pugs can't tolerate extreme summer weather and can easily overheat.

PUG PERK Pugs don't need much space.

THE SEVEN DEADLY SINS OF PUGS

Although Pugs have an almost saintly disposition, they are not entirely angelic. Here is a pie chart serving up some of the dear Pug's most bedeviling traits. How pugapropos!

- **ENVY** Pugs envy any dog with a full bowl.

- **GLUTTONY** Pugs are famous for their voracious appetites. They can hear a refrigerator door opening from three rooms away.

- **GREED** Pugs need a lot of attention and affection. They will be greedy for your time. See *gluttony*.

- **LUST** Nah, Pugs would rather eat.

- **PRIDE** More of a problem with Pug owners than Pugs.

- **SLOTH** Right up there with gluttony. Pugs seem to sleep an average of twenty-two hours a day.

- **WRATH** Only if dinner is late or you're trying to trim their toenails.

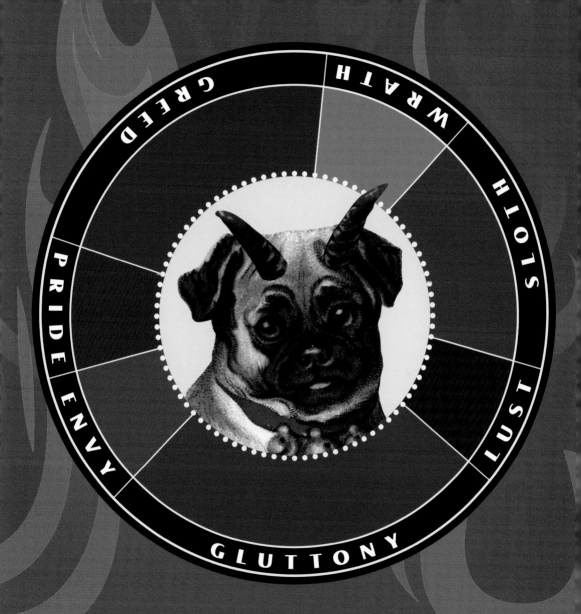

GREED WRATH SLOTH LUST GLUTTONY ENVY PRIDE

THE *Pug* MADE ME BUY IT.

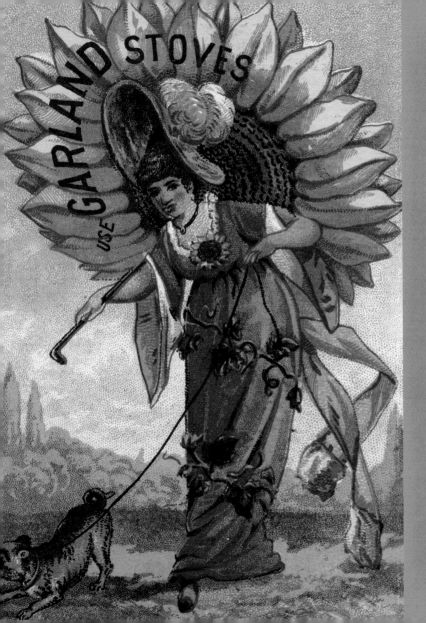

Due in part to Queen Victoria's embrace of the diminutive breed, Pugs loomed large in late nineteenth-century advertising. They appeared on trading cards and commercial ephemera, hawking everything from thread to liver pills, from hair tonic to other medical marvels.

Chinese emperors bred Pugs to have faces wrinkled in patterns that resembled Chinese characters. The most highly prized configuration was three horizontal wrinkles bisected by a vertical bar, which resembled the character for *prince*.

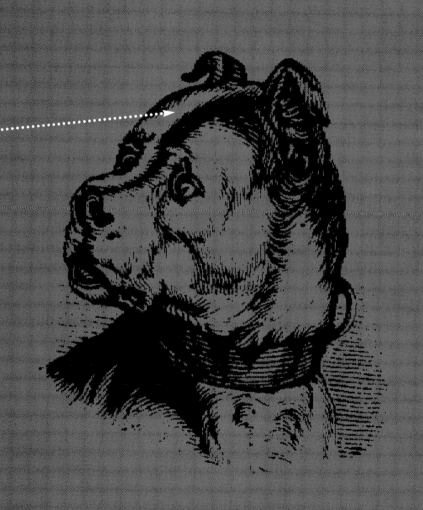

The Pug is living proof that God has a sense of humor.

—Margo Kaufman

Clara, The Story of the Pug Who Ruled My Life, 1998

Althea Garstin (1894–1978).
Precious—A Pug.
Watercolor on paper.
Private Collection
© Manya Igel Fine Arts, London,
UK/The Bridgeman Art Library.

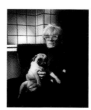

Andy Warhol.
Jill Kennington/Hulton
Archive/Getty Images.

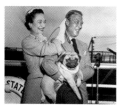

The Duke and Duchess of Windsor.
© Bettmann/CORBIS.

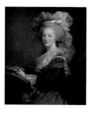

Studio of Élisabeth Louise
Vigée-Lebrun (1755–1842).
Portrait of Marie Antoinette (1755–93).
Private Collection. The Bridgeman
Art Library.

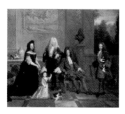

Unknown artist (French School).
*Madame de Ventadour with Portraits
of Louis XIV and Heirs.*
Reproduced by kind permission of
the Wallace Collection, London.

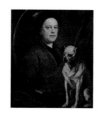

William Hogarth (1697–1764).
The Painter and His Pug, 1745.
Oil on Canvas. Tate Gallery,
London/Art Resource, NY.

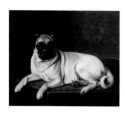

Horatio Henri Couldery
(1832–1910/British).
Waiting for Master—A Pug on a Stool.
Oil on canvas © Christie's
Images/SuperStock.

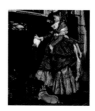

James Jacques Joseph Tissot
(1836–1902).
La Cheminée, 1869.
Oil on canvas. Private
Collection/Photo © Christie's
Images/The Bridgeman Art Library.

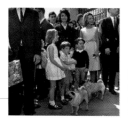

Jacqueline Kennedy, Lee Radziwill,
and children.
© Hulton-Deutsch
Collection/CORBIS.

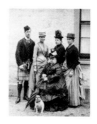

Queen Victoria (seated).
The Royal Collection © 2007,
Her Majesty Queen Elizabeth II.

HarperCollins books may be purchased for educational, business, or sales promotional use.
For information, please write: Special Markets Department, HarperCollins*Publishers*,
10 East 53rd Street, New York, NY 10022.

First Edition

First published in 2008 by
Collins Design,
An Imprint of HarperCollins*Publishers*
10 East 53rd Street
New York, NY 10022
Tel: (212) 207-7000
Fax: (212) 207-7654
collinsdesign@harpercollins.com
www.harpercollins.com

Distributed throughout the world by
HarperCollins*Publishers*
10 East 53rd Street
New York, NY 10022
Fax: (212) 207-7654

Design by Kay Schuckhart/Blond on Pond
kay.schuckhart@gmail.com

Library of Congress Control Number: 2007937062

ISBN: 978-0-06-147592-4

Printed in China
First Printing, 2008

ABOUT THE AUTHOR

Kay Schuckhart is a graphic designer whose clients include Stewart, Tabori & Chang, Rizzoli, Random House, and HarperCollins. She runs her own studio, Blond on Pond, in upstate New York, where she lives with her husband and their two pugs, Peter Francis and Peggy.